GUILDFORD
HISTORY TOUR

Map contains Ordnance Survey data © Crown Copyright and datatbase right [2015]

First published 2009
This edition published 2015

Amberley Publishing
The Hill, Stroud,
Gloucestershire, GL5 4EP
www.amberley-books.com

Copyright © David Rose and
Bernard Parke, 2015

The right of David Rose and
Bernard Parke to be identified as the
Authors of this work has been asserted
in accordance with the Copyrights,
Designs and Patents Act 1988.

ISBN 978 1 4456 5442 3 (print)
ISBN 978 1 4456 5443 0 (ebook)

British Library Cataloguing in
Publication Data.
A catalogue record for this book is
available from the British Library.

Typesetting by Amberley Publishing.
Printed in Great Britain.

INTRODUCTION

If a Guildfordian of the Edwardian era could walk the same streets today he would obviously recognise the Guildhall and its famous clock. He'd find the attractive Castle Grounds very much unaltered. A stroll along the River Wey to St Catherine's and the meadows beside Shalford Park would be mostly familiar. Buildings such as the Royal Grammar School and St Mary's, St Nicolas' and Holy Trinity churches would be useful landmarks to indicate where he was. Of course, there are many other buildings still standing that would look the same, but he'd probably be amazed at their use today. For example, the fire station in North Street is now a public lavatory and what was the Bull's Head pub no longer serves up beer but is currently a shop.

If he went to the railway station he wouldn't recognise it at all. He'd lose his bearings in North Street as some fine buildings that once stood on the north side, including the post office and the Borough Halls, have all long gone. The Friary Brewery has been replaced by the Friary Shopping Centre and if he walked along Onslow Street he wouldn't know where he was. In his day he'd have known the cattle market in Woodbridge Road well. Would he believe that on that site now are the police station and the law courts? *Guildford History Tour* reflects the changing scenes of Surrey's county town. Not all the old photos in this book date from the halcyon years of the picture postcard, which lasted from the 1900s to about the 1930s. There are a number of photos taken around the 1950s and '60s when much development was taking place that changed the landscape and skyline of Guildford town centre forever.

We hope you enjoy this 'tour' of the town; see how many changes you can spot.

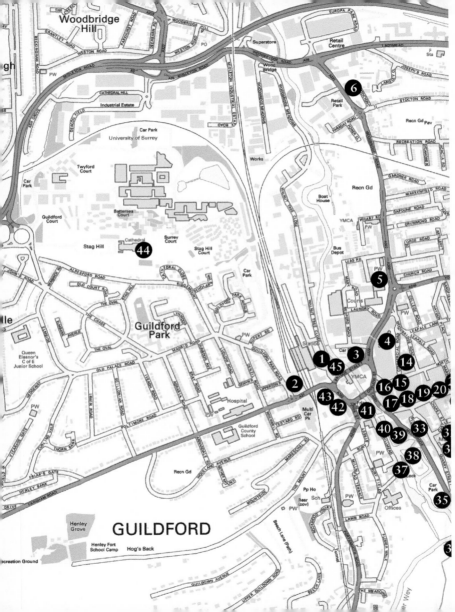

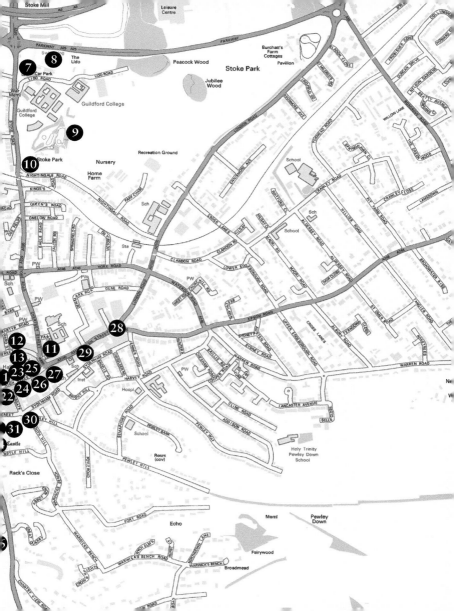

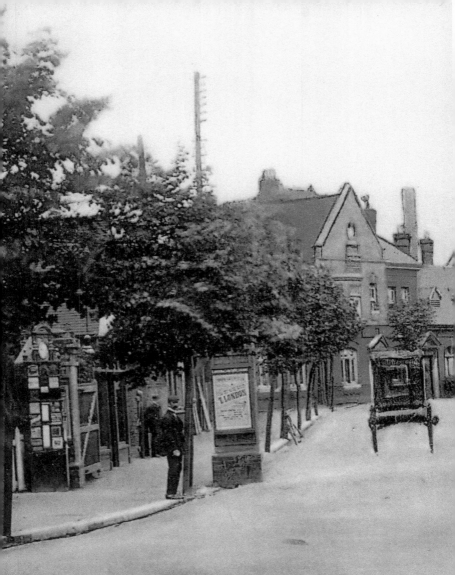

Guildford Railway Approach.

1. GUILDFORD RAILWAY STATION APPROACH

This historical tour of Guildford starts at the railway station where many people alight or catch trains to destinations such as London, Portsmouth, Reading and Redhill. The railway came to Guildford in 1845, and soon after the town began to expand as never seen before. The station was largely rebuilt in 1888 and remained virtually unchanged for 100 years. Today's station buildings were constructed in 1988. At the time of writing (2015) plans have been submitted that may see this side of it rebuilt with possibly some high-rise buildings incorporating shops and offices.

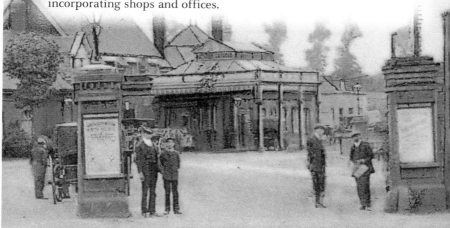

2. FAREWELL TO THE ENGINE SHED

Viewed from the Farnham Road bridge, the double-headed steam train was on a rail tour when it came through Guildford on 3 April 1966 and is seen passing the engine shed. When British Rail withdrew steam locos on the Southern Region in 1967, the shed was closed. This viewpoint, and at the end of the platforms, had been a popular place for trainspotters to watch the engine movements at the shed. After the shed buildings were demolished and the site cleared it remained an empty space for some time until a multi-storey car park was built there.

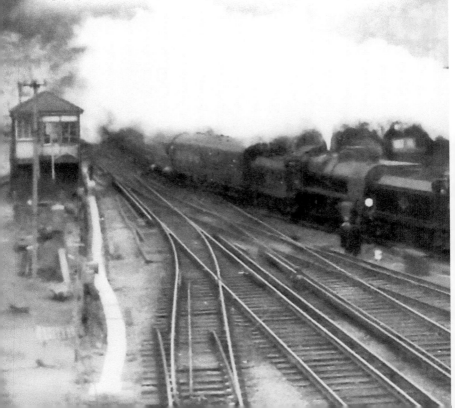

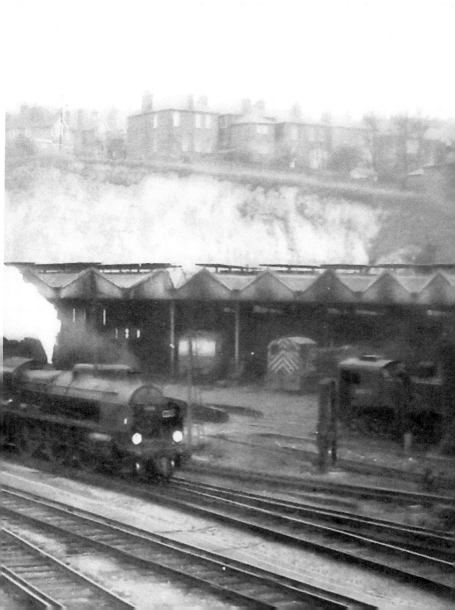

nslow Street, Guildford.

3. PICTURE PALACE CINEMA TO NIGHTCLUB AND BARS

The Picture Palace cinema is seen here in the early twentieth century, with Shelvey's mineral water factory next door (to the right). The latter became the offices and printing works of the *Surrey Times* newspaper until 1964, while the cinema later changed its name to the Plaza. In the 1960s it also hosted live music with then up and coming bands such as The Who, as well as American blues legends, including Howlin' Wolf and Sonny Boy Williamson playing there. Later it became a bingo hall. Today, these buildings are nightclubs and bars owned by local entrepreneur Michel Harper, and there are plans for it to be redeveloped.

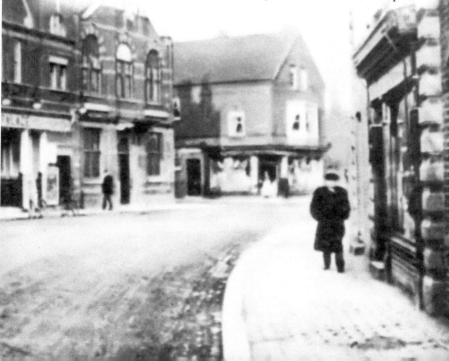

4. ST SAVIOUR'S CHURCH

St Saviour's Church was newly built when this early 1900s picture postcard view was taken. It replaced a short-lived red-brick church that was on the opposite site of the road, which itself had replaced a 'tin' chapel dating to 1876. Today this Anglican church in Woodbridge Road thrives, with large congregations and visitors to the services of worship and events that take place throughout the week. It has been extended to the left on two floors and some of the rooms are available to hire for meetings and conferences.

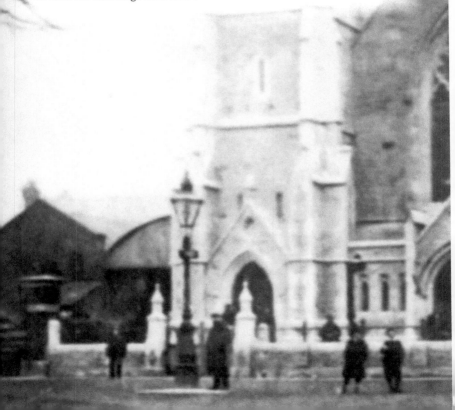

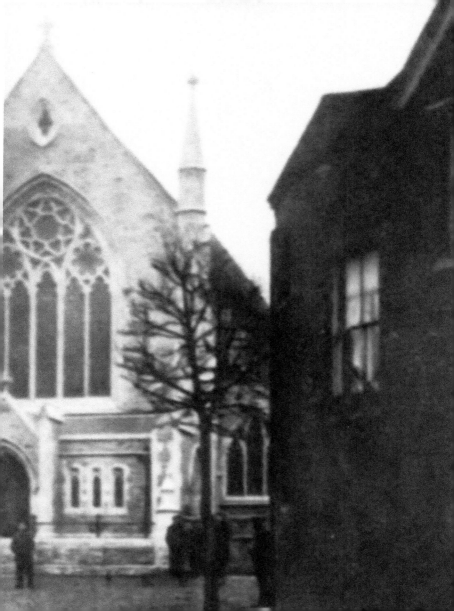

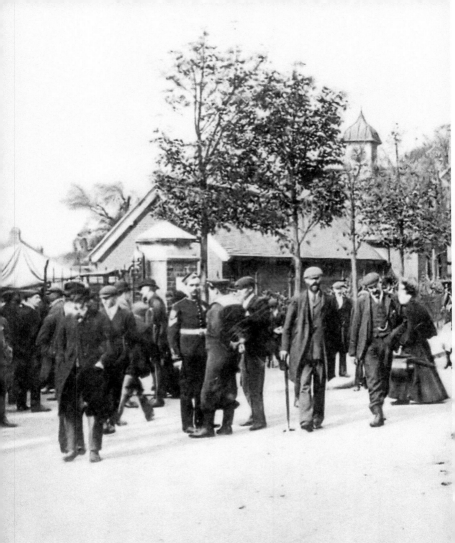

MARKET DAY. WOODBRIDGE Rᴰ. GUILDFORD.

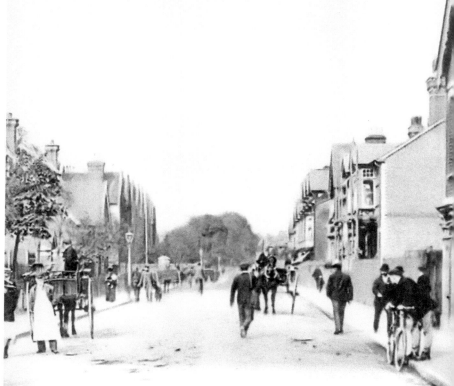

5. WOODBRIDGE ROAD AND THE CATTLE MARKET

People stand in the road, some having an idle chat, in another Edwardian view that appears to have been taken on market day. The cattle market was held here every Tuesday from 1896 after it moved from North Street. It was later transferred to Slyfield Green, although today this historic market town no longer has a livestock market. Today, Guildford police station occupies part of the former market site.

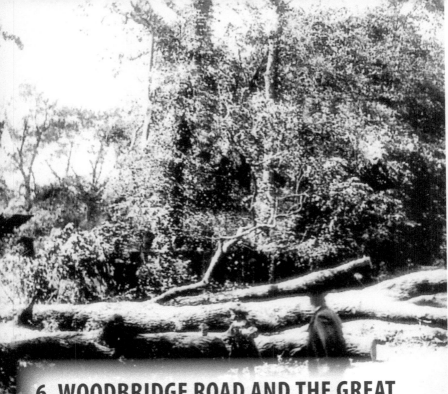

6. WOODBRIDGE ROAD AND THE GREAT STORM OF 1906

It was near this spot that Ruth Blunden, aged twenty-three, and Charles Voice, aged fourteen, died when trees they were sheltering under fell on them, brought down by Guildford's Great Storm on 2 August 1906. The storm featured terrific flashes of lightning and ferocious thunder claps. This photo must have been taken a short time afterwards when the fallen trees that had blocked the road had been cleared. Today, there is nothing whatsoever to indicate that this stretch of Woodbridge Road had once been a leafy thoroughfare.

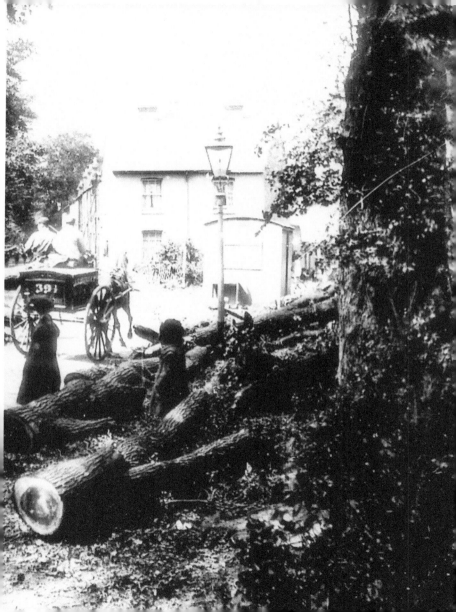

7. ST JOHN'S CHURCH, STOKE ROAD

For centuries, St John's Church, Stoke-next-Guildford, must have stood in relatively open countryside. Stoke Road, on which it stands, is now one of the busiest thoroughfares into the town centre. Admiral Sir James Stirling (1791–1865), the first governor of Western Australia married Ellen Mangles there on 3 September 1823 on her sixteenth birthday. She was from a wealthy Guildford family. In their later lives they returned to Guildford and are buried in the churchyard. However, the exact location is something of a mystery as it seems their bones have been moved. At the time of writing (2015) the church has plans to raise funds by selling off the west churchyard, (seen in the picture). All remains would be carefully removed and reburied near to the church itself.

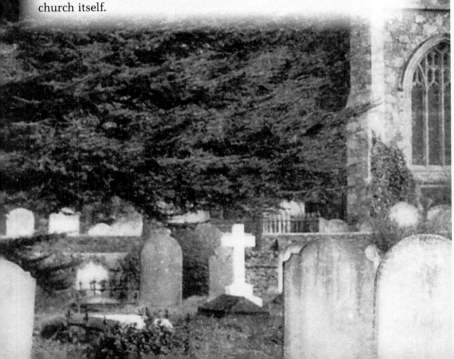

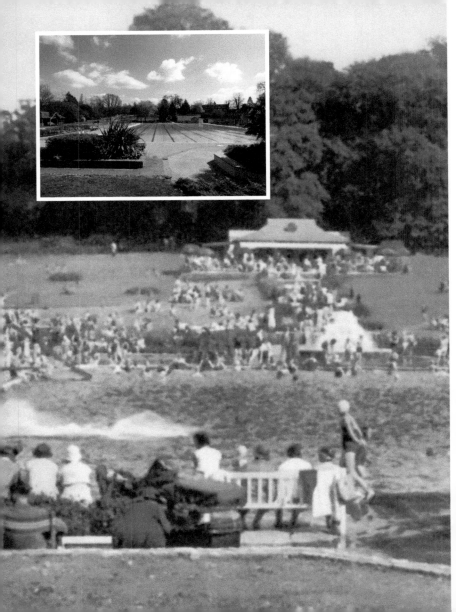

8. THE LIDO

Opened at a cost of £13,700 in 1933, the Lido is still a popular place for swimming and sunbathing – weather permitting. The open-air pool was built largely by unemployed men during the Depression. They had been given jobs funded by a pioneering scheme set up by Guildford's then mayor William Harvey. He called it the Work Fund and Guildfordians who were earning a wage, or who were suitably well off, were asked to contribute in whatever way they could to support it. For his efforts, in 1934 William Harvey was appointed OBE. He was also rewarded with the honorary freedom of the borough of Guildford.

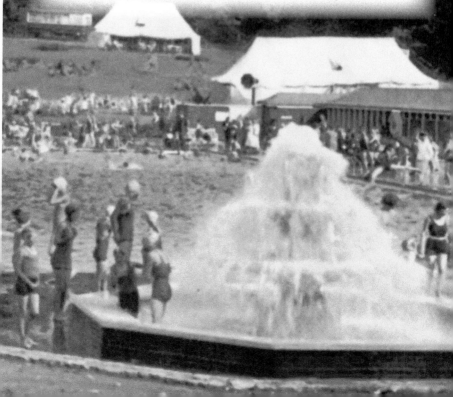

9. THE BOATING POND, STOKE PARK

The 186 acres of Stoke Park were purchased by Guildford Corporation in 1925 to be used as a public open space. In 1935, as part of the town's celebrations of the silver jubilee of George V, an ornamental Japanese-style paddling pool, rock garden and boating pond was opened. In 1943, during the Second World War, two RAF Mustangs collided in mid-air and crashed in the park, killing both pilots. Today the park hosts the annual Surrey County Show, music festivals and in 2015 was the venue for the Armed Forces Day national event.

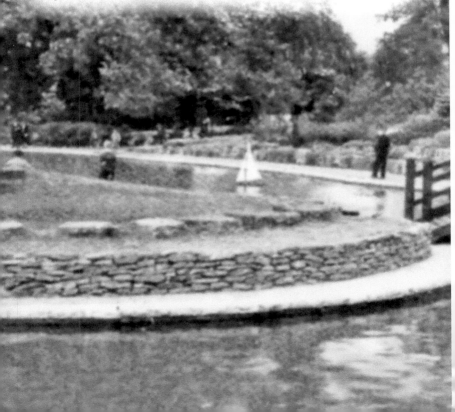

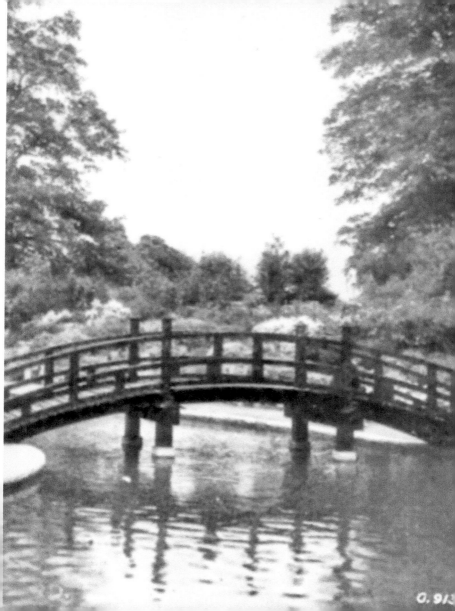

O. 91

10. NIGHTINGALE ROAD

In this Edwardian photo, a mass of trees and bushes behind the wooden fence screen off the grounds of Stoke Park Mansion, then used as a school. At one time there was a plan to site the technical college here on the corner of Stoke Road and Nightingale Road. Other interesting schemes that were later quietly dropped included a plan to build homes on large parts of Stoke Park. Those who live in the houses here today still have attractive views across the much-appreciated open space.

Nightingale Road, Guildford.

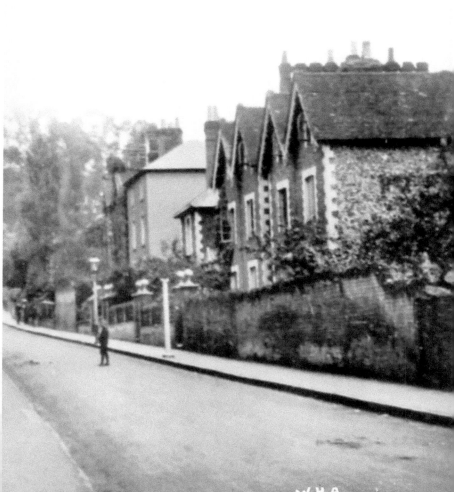

W.H.A
Photo Series. No. 275.

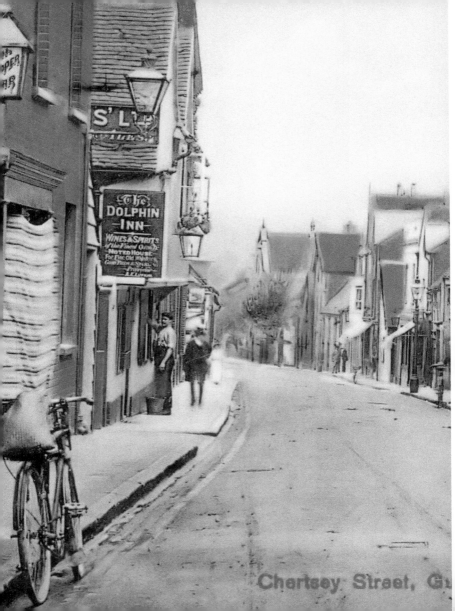

Chertsey Street, G

11. CHERTSEY STREET

Two pubs, now long gone, were once here in Chertsey Street. On the left was the Dolphin Inn and the little way further down on the right was the Leopard. Further down on the right the Guildford Tup remains, but for many years it was called the Spread Eagle. Softer drinks in the form of fizzy lemonade and ginger beer were made at the far end of the road, towards Stoke Road. From 1900 until 1925 Messers R. White & Sons had a mineral water factory there, the building later used as a Unigate diary.

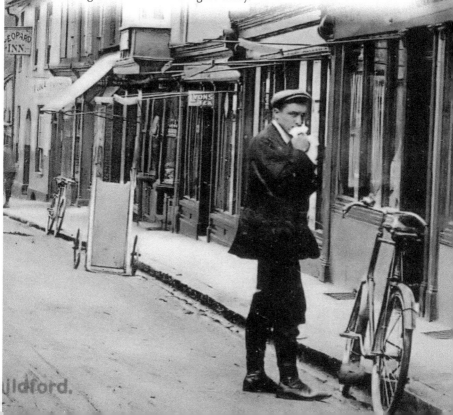

12. OLD FIRE STATION IN NORTH STREET

This 1920s view shows the fire station when it was in North Street. It was opened in 1872 and was used until the brigade moved to a new building in Ladymead in 1937. Recently, a brand-new fire station has been opened next to that one. Today the North Street building is a public lavatory. It seems a shame that the words 'GUILDFORD FIRE BRIGADE ENGINE HOUSE' are no longer visible along the front and side of it.

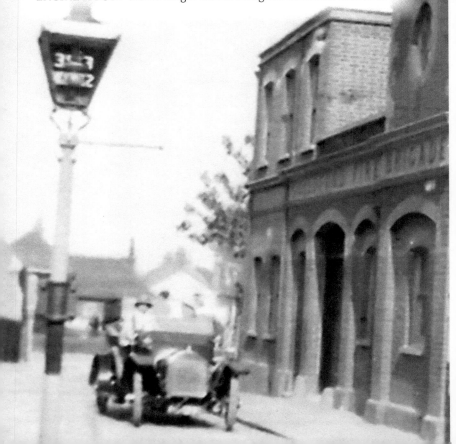

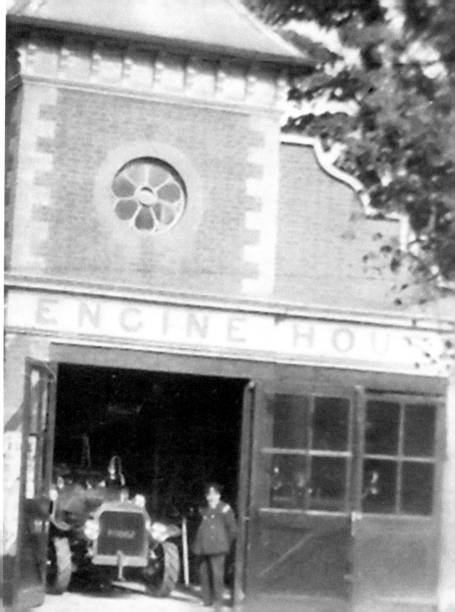

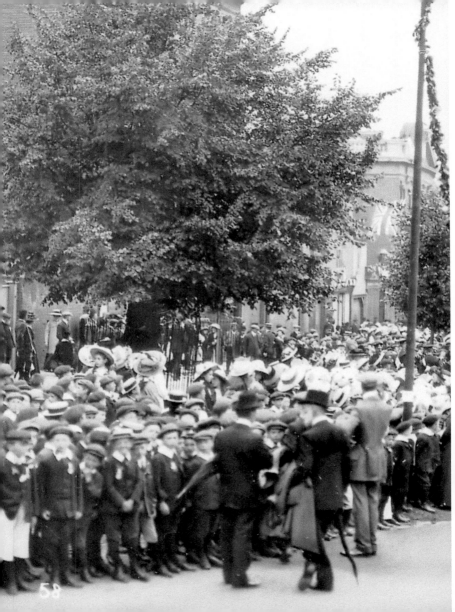

58

13. GEORGE V'S CORONATION CELEBRATIONS IN NORTH STREET

A large crowd has gathered in North Street to watch the Grand Procession of some thirty-seven floats as part of Guildford's celebrations to mark George V's coronation on 22 June 1911. At that time Guildford's population was about 20,000. It seems that just about everyone made their way into the town that day to mark the event. On the right can be seen a part of the Guildford Institute. It continues to thrive today and has a fascinating archive of old photographs, newspaper cuttings and ephemera relating to Guildford.

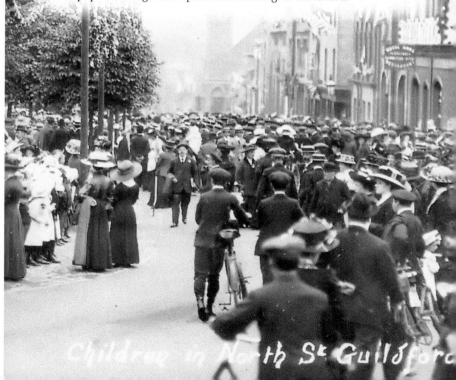

Children in North St Guildford

14. SAD NEWS AT THE POST OFFICE

Guildford's earlier red-brick post office can be seen in this photo from the 1910s. It was here that the American writer Mark Twain, while briefly staying in Guildford, spent a night waiting for a cable containing news of the condition of his sick daughter. When it came, it confirmed that sadly she had died. The post office building was replaced by a new one in 1972. It remains, but most would agree it has never blended in with its surroundings. The Methodist church, with its tall spire, also no longer exists. It was demolished in 1973.

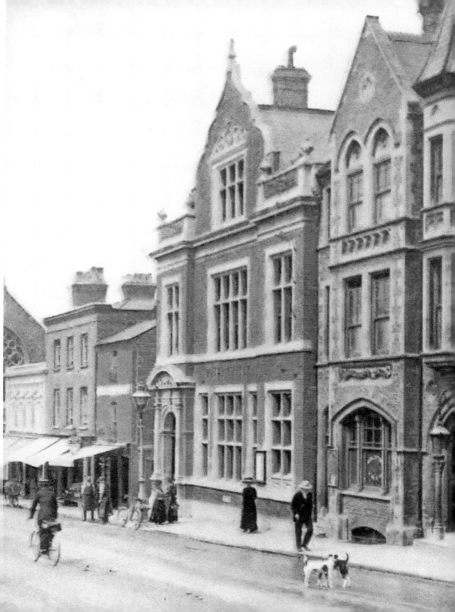

15. WOOLWORTH'S TO WHITE LION WALK

Many will fondly remember the store F. W. Woolworth, or 'Woolies' as it was often known. At one time it was located here with an entrance on North Street as well as High Street. The food hall was at this end of the store, with clothing, the records department and other goods sold at the other end. To the left can be seen the Little White Lion pub. Before Woolworth's, the site was occupied by the grand Lion Hotel. It is now the White Lion Walk shopping mall.

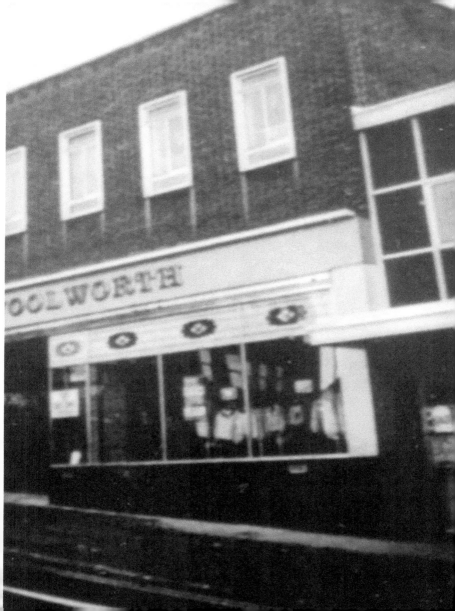

16. FRIARY STREET

Today it's hard to believe that traffic used to pass up and down Friary Street and that there was even a petrol station here! It was pedestrianised in the 1970s. In this view, taken a few years after, shops included Hardy's menswear, Delgety frozen foods and Tesco. Friary Street has recently had a major revamp. Part of the façade of one of its old buildings, formerly the Bear pub, can still be viewed on the east side.

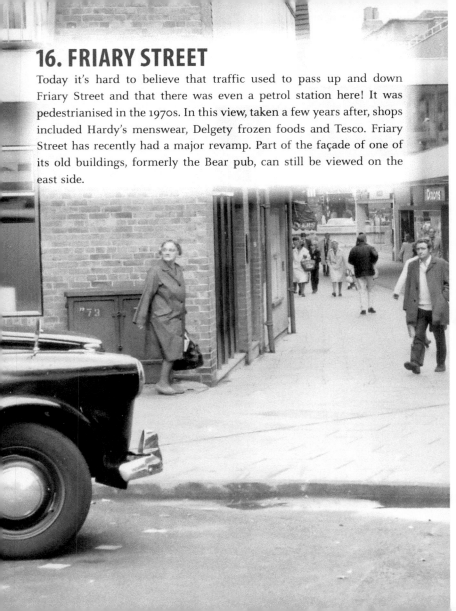

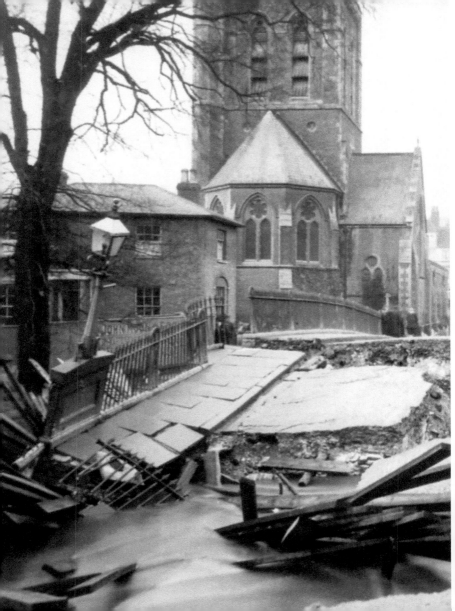

17. THE TOWN BRIDGE

A swollen river dislodged timbers at Moon's yard (where the Debenhams store is today) and brought them crashing into the town bridge in January 1900 causing some spectacular damage. The bridge was completely rebuilt, opening two years later. However, much of the structure that spans the River Wey today dates back to 1985. And although its reconstruction can allow motor vehicles, its use is for pedestrians only. Ongoing plans for Guildford's development and road system may see it once again used by vehicles.

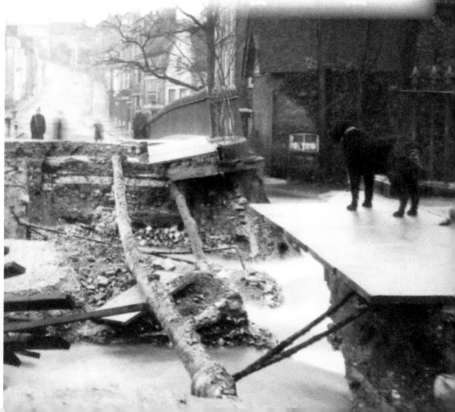

18. FLOODS AT THE FOOT OF THE HIGH STREET

This picture shows just how deep the flood water was at the bottom of the High Street near the corner of Friary Street in September 1968. As the water flooded into the shops on a Sunday night and the early hours of the Monday, there was, of course, no one around to salvage the goods. As a result, thousands of pounds worth of stock was ruined. 'Bodies' were reported floating in the water, but they turned out to be tailors' dummies! People flocked into Guildford to see the floods and the damage that had been done.

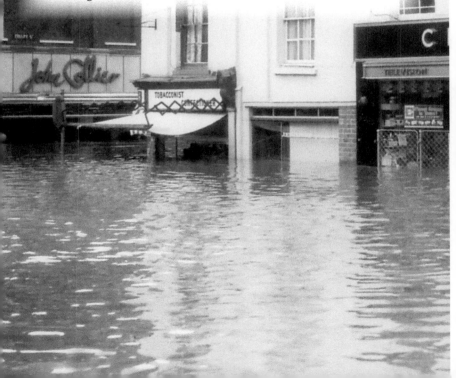

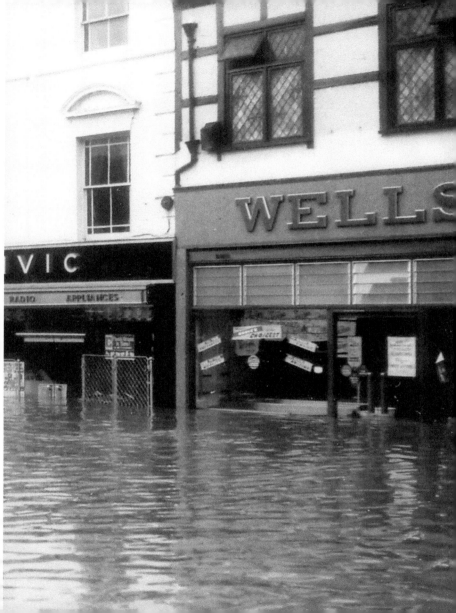

19. THE ANGEL HOTEL

The Angel Hotel is the only survivor of Guildford's once prestigious coaching inns that were on the route from London to Portsmouth. There appears to have been an inn on this site since at least the sixteenth century, and there are a number of ghost stories attached to it. Perhaps the most famous one is of the figure of a man that appeared in a mirror to guests staying there in 1968. While a national newspaper reported in 1973 that when the actor Roger Moore was a guest there he was visited two nights running by the apparition of a man. And in 1985, two days before Hallowe'en, staff said they heard ghostly voices.

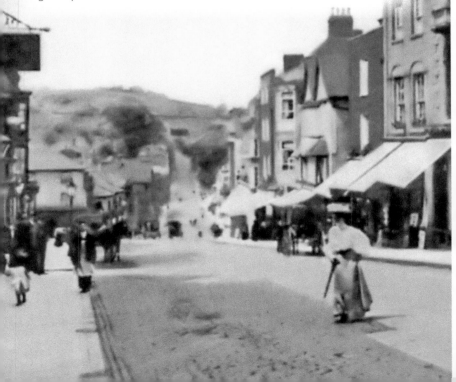

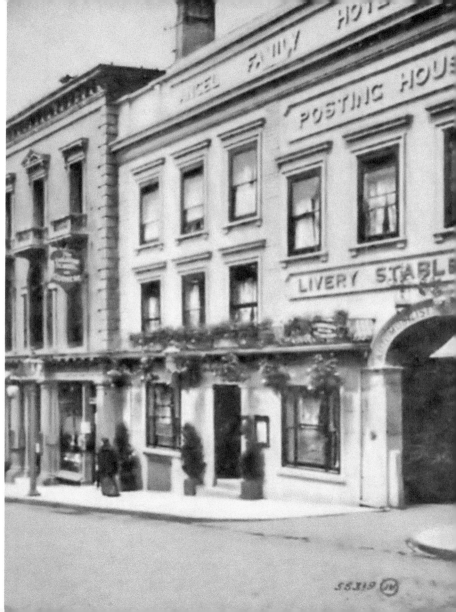

20. ROOF GARDEN

Landscape architect Sir Geoffrey Jellicoe designed the rooftop garden on Harvey's department store in 1956–57. He later wrote that it was in part inspired by the first Sputnik spacecraft at that time flying high above the earth. As a result, the garden had a number of swirling and circular features reminiscent of the planets. Along with its restaurant and the goldfish in the ponds, the roof garden was a popular place to visit in the 1960s. It was later closed after some items of furniture were recklessly thrown from the roof. However, in recent years, when the store, now House of Fraser, received a substantial revamp the roof garden was reinstated and is again part of the restaurant on the top floor.

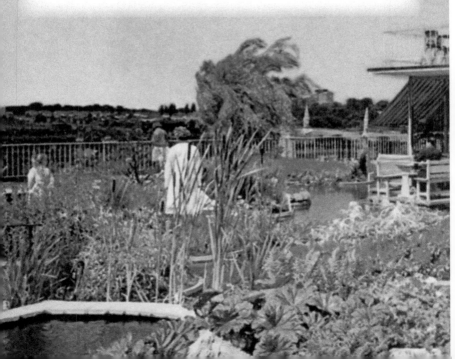

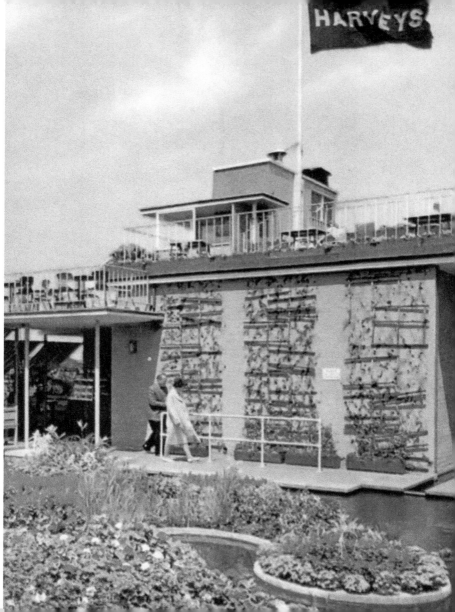

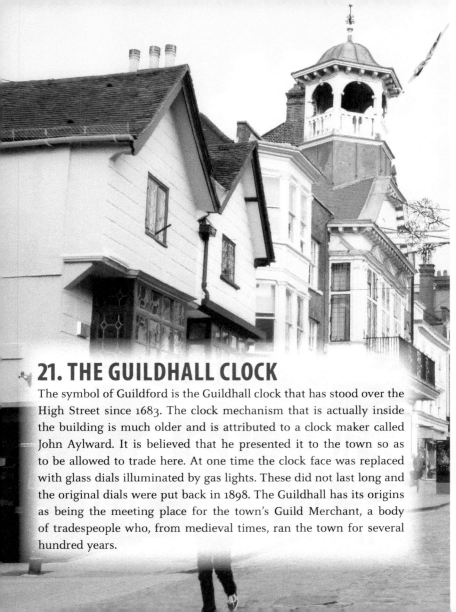

21. THE GUILDHALL CLOCK

The symbol of Guildford is the Guildhall clock that has stood over the High Street since 1683. The clock mechanism that is actually inside the building is much older and is attributed to a clock maker called John Aylward. It is believed that he presented it to the town so as to be allowed to trade here. At one time the clock face was replaced with glass dials illuminated by gas lights. These did not last long and the original dials were put back in 1898. The Guildhall has its origins as being the meeting place for the town's Guild Merchant, a body of tradespeople who, from medieval times, ran the town for several hundred years.

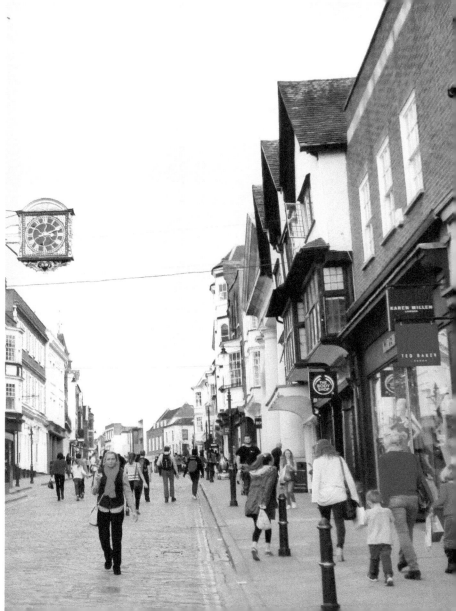

22. TUNSGATE ARCH

It was once said that Tunsgate was a gateway to nowhere. It was built in 1818 as a covered corn exchange at a time when Guildford's market was in the High Street. Part of the building was also used as a court for the assizes. This picture, from the 1900s, taken soon after the corn market had been transferred to Woodbridge Road, shows the stone pillars equally spaced. In the 1930s the middle two were moved to create room for motor-vehicles to pass through to a car park behind. In more recent times the arch was closed to traffic and the steps reinstated. It takes its name from the Three Tuns Inn that previously stood here.

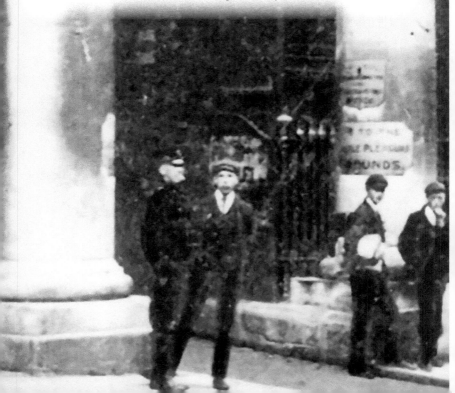

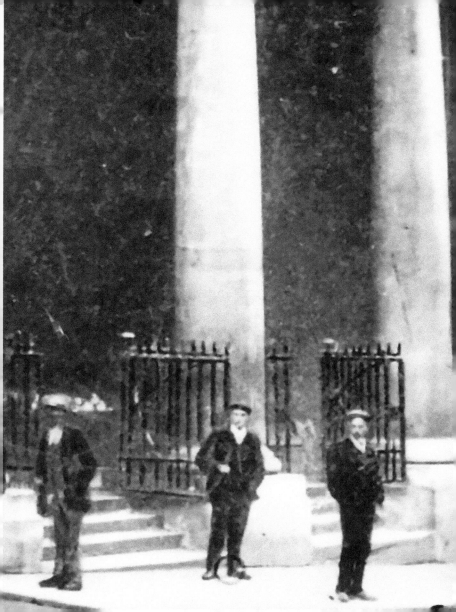

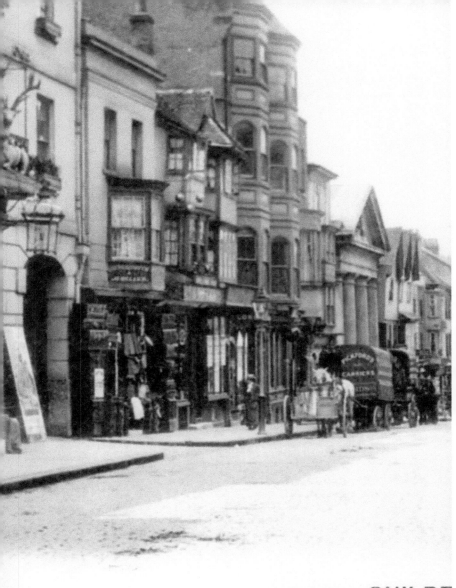

HIGH STREET, GUILDF

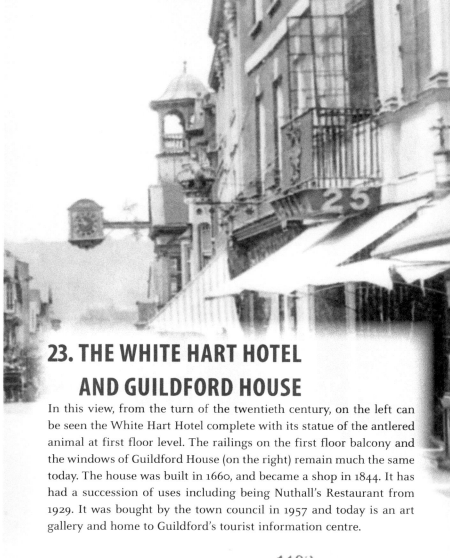

23. THE WHITE HART HOTEL AND GUILDFORD HOUSE

In this view, from the turn of the twentieth century, on the left can be seen the White Hart Hotel complete with its statue of the antlered animal at first floor level. The railings on the first floor balcony and the windows of Guildford House (on the right) remain much the same today. The house was built in 1660, and became a shop in 1844. It has had a succession of uses including being Nuthall's Restaurant from 1929. It was bought by the town council in 1957 and today is an art gallery and home to Guildford's tourist information centre.

ORD.

1192 LLOYD. GUILDFOR

24. SAINSBURY'S AND THE COUNTY CLUB

Sainsbury's replaced the White Hart in 1905 and later extended further down the street. It became a self-service supermarket in 1962. In this view, taken around the 1960s, the ground floor of the white building is home to Fuller's confectioners and Lloyds Photographic Centre. Above was, and still is, the County Club – at one time a regular haunt of Guildford's 'movers and shakers'.

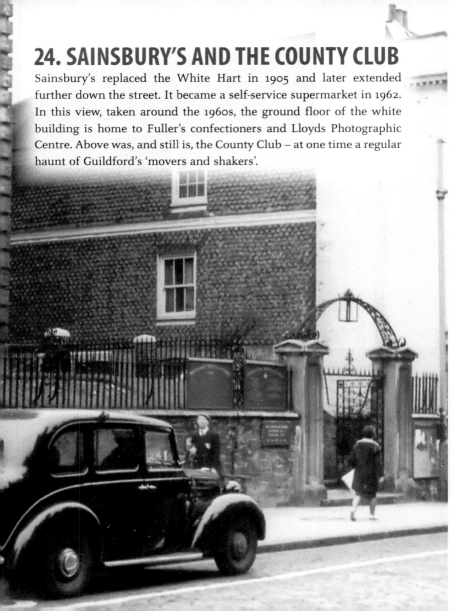

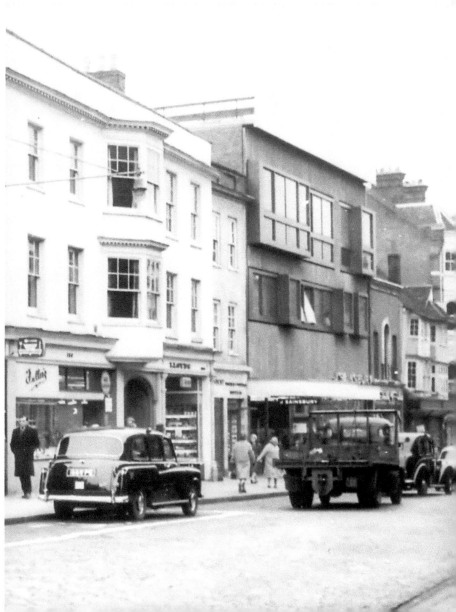

25. ABBOT'S HOSPITAL

Abbot's Hospital is perhaps Guildford town centre's most spectacular building. Archbishop George Abbot, the town's most famous son, laid the foundation stone in 1619. It was his gift to the town of his birth – an almshouse that when completed had accommodation for twenty senior citizens of the town. And it continues to be used for that purpose today, with the addition of extra apartments behind that were built in 1984. It is, without doubt, one of the best examples of Tudor brickwork in the south of England and is reminiscent of certain Oxford and Cambridge colleges.

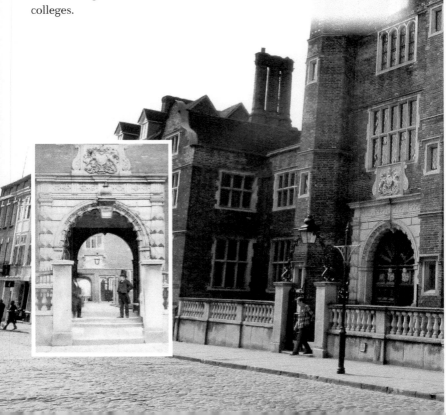

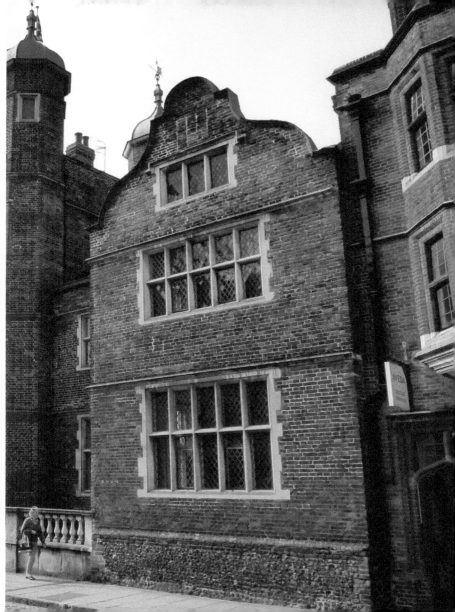

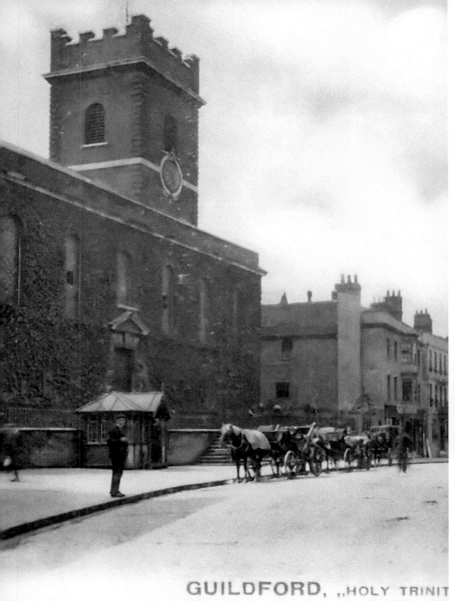

GUILDFORD, "HOLY TRINIT

26. HOLY TRINITY CHURCH

Ivy adorns the north wall of Holy Trinity Church in a view taken around 1900. The church was consecrated in 1763, replacing a medieval church that had to be pulled down when its tower collapsed in 1740. It became the cathedral church of the new Diocese of Guildford in 1927, prior to the Cathedral of the Holy Spirit being built on Stag Hill. The Three Pigeons pub on the right carries that name once more after being renamed the Farriers for a few years just recently.

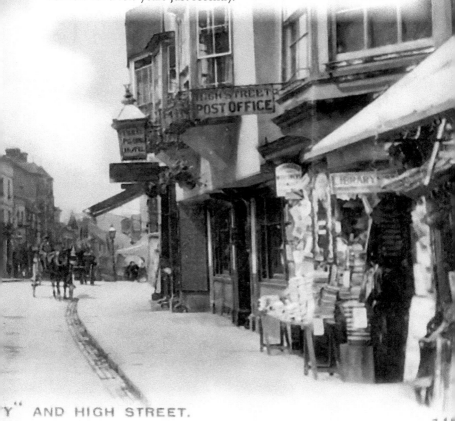

Y" AND HIGH STREET.

27. UPPER HIGH STREET

Once known as 'Spital Street', a shortening of 'Hospital Street' after a hospital that had stood near its junction with Epsom Road, it was renamed in 1901. During the 1950s it was decided to demolish the existing buildings on the left of the photograph. Replacement buildings were only supposed to be temporary but have stood the test of time and remain to this today. Barfoot's Paperhanging and Decorative Warehouse is on the left of the photo that is from the 1900s. The original owner of this firm was Joseph Whitaker Barfoot, founder of the *Surrey Advertiser* newspaper in 1864.

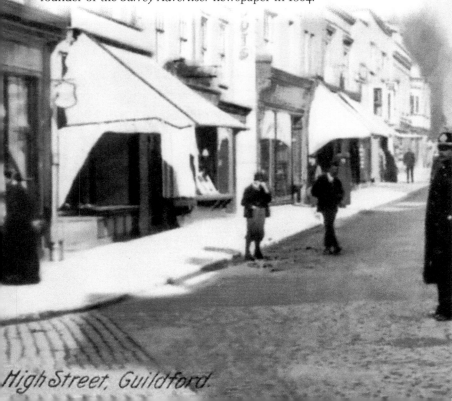

High Street, Guildford.

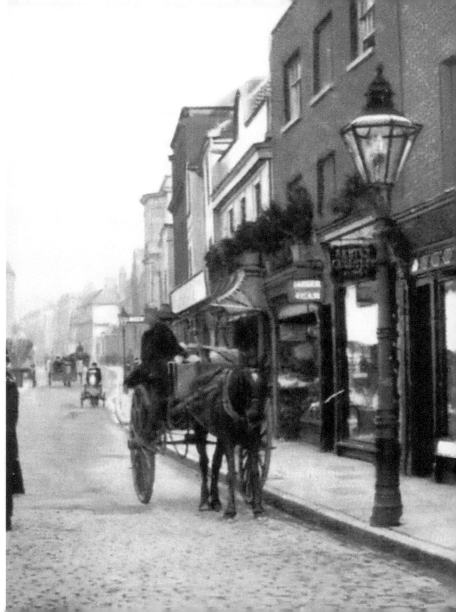

28. UPPER HIGH STREET WITH THE JUNCTION OF EPSOM ROAD

Behind the trees in this Edwardian photograph was the imposing buildings and grounds of Belmont House. It was demolished during the 1930s and replaced by the Prudential Buildings. The building on the right hand side was for many years the White Horse Hotel and is now a bar. Note the ornate gas lamp to the left. It features direction signs to all points of the compass.

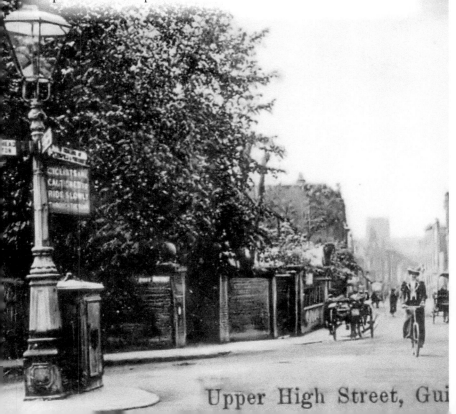

Upper High Street, Gui

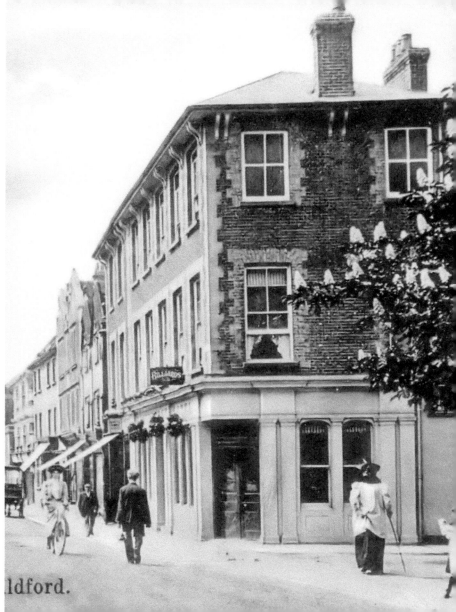

ldford.

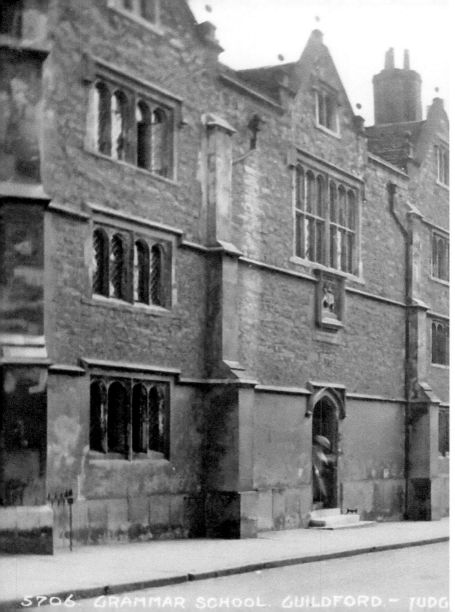

5706. GRAMMAR SCHOOL. GUILDFORD.— TUDO

29. ROYAL GRAMMAR SCHOOL

The imposing facade of the Royal Grammar School has hardly changed, except that it is now painted white. Robert Beckingham, a wealthy London merchant, bequeathed money in his will for the building of a free school in Guildford. The town petitioned Edward VI for funds for its maintenance. Building work began in 1557. A fire in 1962 caused some damage, but luckily the building was saved. The 'new' part of the Royal Grammar School, on the opposite side of the road, was opened a few years later and in 1977 the school became independent and fee paying.

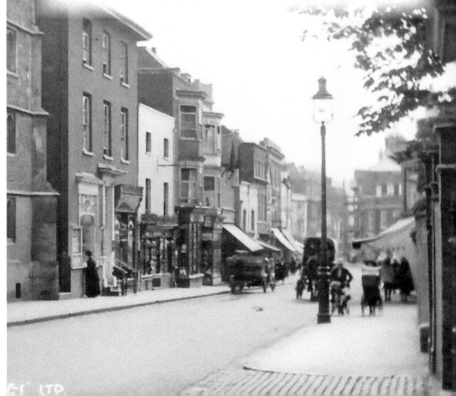

30. CAR PARK IN SYDENHAM ROAD

Demolition had been taking place in this 1959 photograph to make way for a multi-storey car park, which was opened in 1963. In the 1990s it was found to be structurally unsafe. It was pulled down and replaced by the new Castle Car Park, its architecture a visual improvement on the previous building. In this view there is a glimpse of Holy Trinity church and Abbot's Hospital. The cars of the time are of interest too.

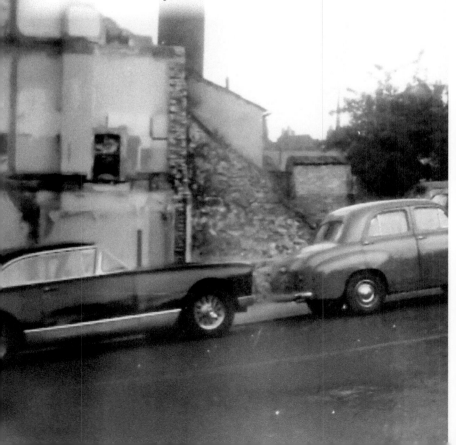

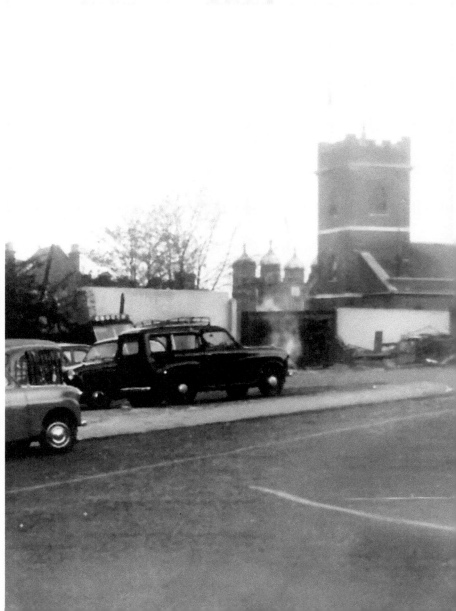

31. THE CASTLE KEEP

The stone keep of Guildford Castle was built in the twelfth century following earlier fortifications believed to have been started soon after the Norman invasion of 1066. It was frequented by a number of royal visitors during the medieval period, including King John and Henry III. It was then mostly abandoned and in 1611 James I sold it to a Guildford man, Francis Carter. Guildford Corporation purchased the castle buildings and its grounds from Lord Grantley in 1885 for £4,490, opening them to the public in 1888.

32. HENRY PEAK'S POND

Guildford's Victorian town surveyor Henry Peak designed the layout of the Castle Grounds including many attractive features. The pond was another of his clever designs. Having a slightly different layout today, it has now had some restoration work and is still a popular spot for young and old alike. Nearby, the Castle Green Bowling Club plays its matches on what must be one of the most picturesque bowling greens for miles around.

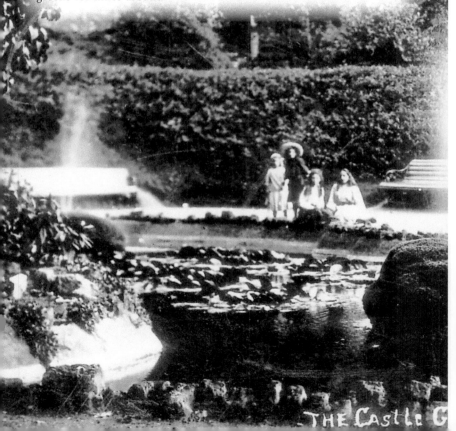

THE Castle G

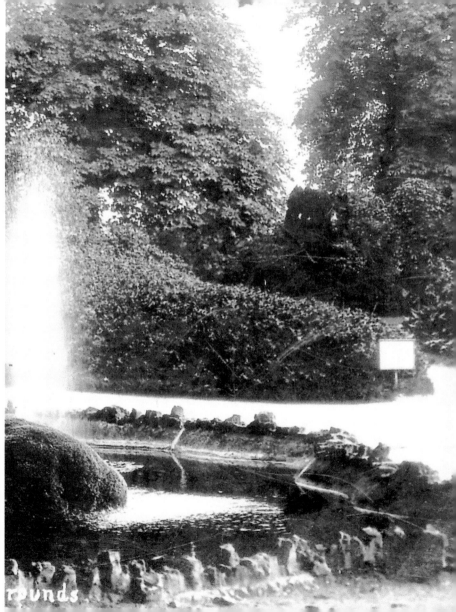
rounds

33. ST MARY'S CHURCH

The tower of St Mary's church dates back to Saxon times making it the oldest building in the town. In recent years the church has been re-roofed and the stonework repointed. Inside, the Victorian wooden pews have been removed and replaced by comfortable modern chairs. As well as a place of worship, St Mary's also holds secular events such as concerts. The writer Lewis Carroll (real name the Revd Charles Lutwidge Dodgson) rented a house called the Chestnuts in Castle Hill for his unmarried siblings, and when visiting from his home in Oxford sometimes preached in the church.

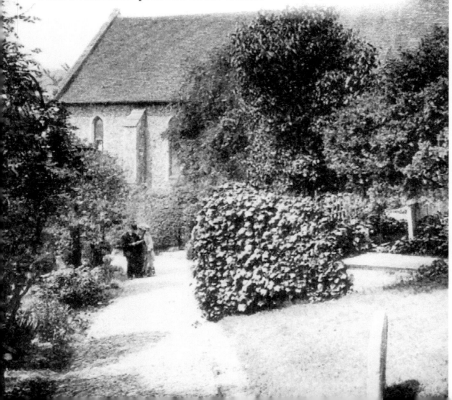

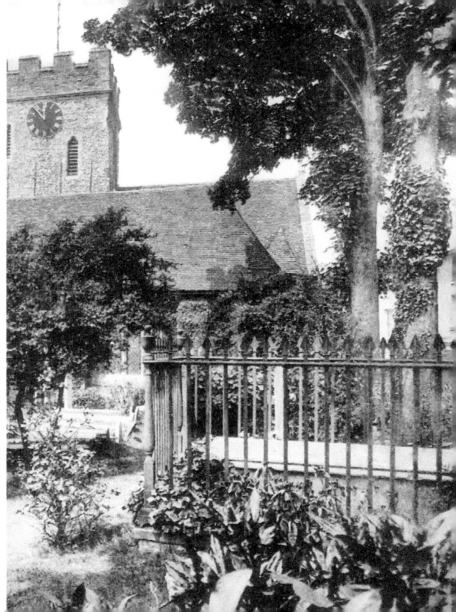

34. CASTLE ARCH

Henry III's master mason, John of Gloucester, is believed to have built the impressive stone arch in 1256 that formed a gateway to Guildford Castle. It is made of a hard type of chalk known as clunch. With traffic allowed to past through the narrow arch in both directions, it is not surprising that on one occasion (in 1978) it was hit by a lorry that caused some damage to the structure. The building on the right dates back to 1638 and is part of Guildford Museum.

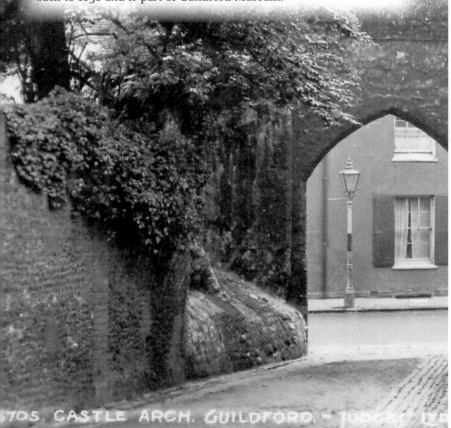

705. CASTLE ARCH. GUILDFORD. - JUDGES' LT

BOATHOUSE

LEROY'S

on Tea

River Bank. Guildford.

35. BOATHOUSE BESIDE THE RIVER WEY

Our Guildford forebears certainly enjoyed leisure pursuits that took advantage of this lovely stretch of the river. There were once two boathouses here, Allen's and Leroy's. They hired out all kinds of rowing boats, canoes and punts, while also offering teas and refreshments. This view shows the earlier Jolly Farmer pub. Therefore, it must date prior to 1913, when the present pub was built. It is now called the Weyside. Nevertheless, it is still a very popular spot.

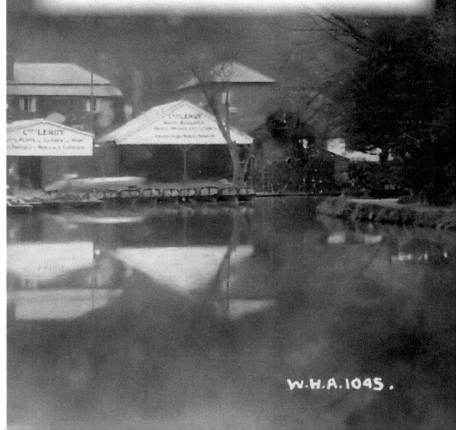

W.H.A. 1095.

36. FOOTBRIDGE ACROSS THE RIVER

The man standing up in the punt seems to be pushing his luck a bit! But it looks a glorious day to have been out on the water. The view also shows a wooden footbridge linking Shalford Road with the towpath. The bridge that stands today was opened in 1934, replacing the earlier one that had rotted away. Guildford Rowing Club is based on the site where this photo was taken. However, many years ago concert parties, in the style of end-of-the-pier shows, were held here inside a building called the Paddock Gardens.

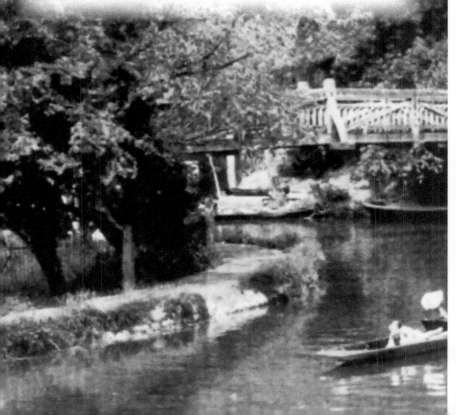

Guildford

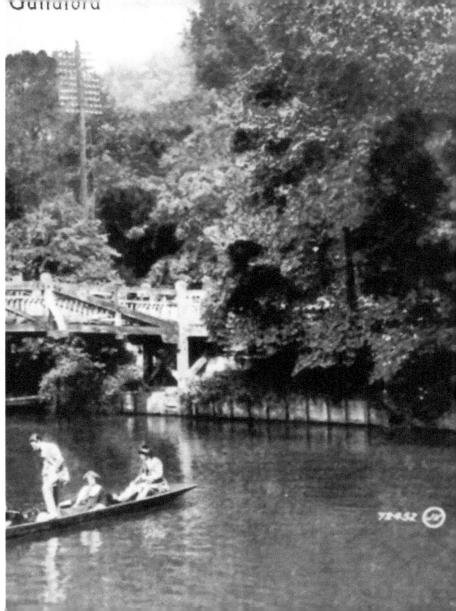

37. FLOODING AT MILLMEAD

Anyone who lived in Guildford through the first couple of decades of the twentieth century would have seen the River Wey burst its banks on several occasions, flooding parts of the town. A number of photos were taken of the floods in January 1925 and issued as picture postcards. Here we see the footbridge at Millmead. The most recent floods were at Christmas 2013. The river once again rose to about the same height at this spot.

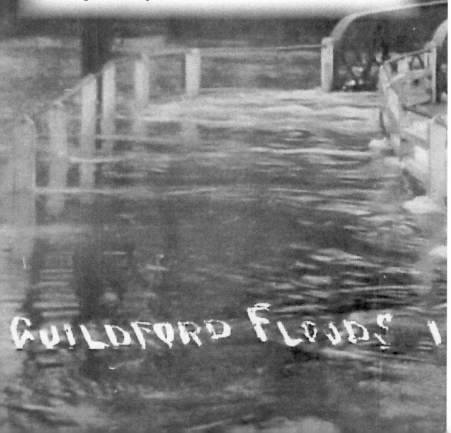

GUILDFORD FLOODS 1

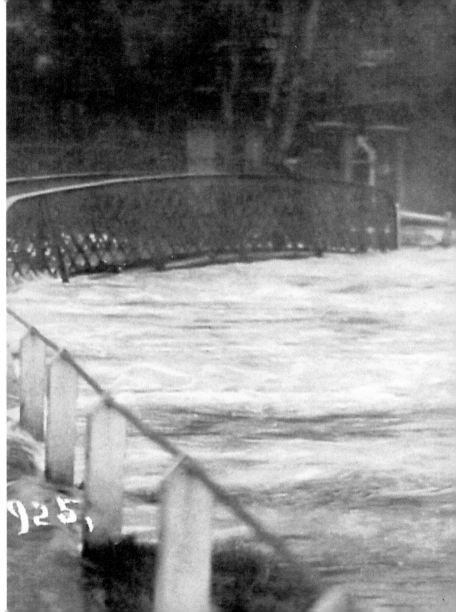

925,

38. SITE OF THE YVONNE ARNAUD THEATRE

In this view, the foundations have been laid and construction work is starting on the Yvonne Arnaud Theatre. There had once been a foundry on this site. The theatre opened in 1965 with a gala evening with special guests from the world of drama including Lord Olivier and Dirk Bogarde. Unfortunately, the theatre suffered due to the floods of 1968 and again in 2013. During the latter, the mopping up was done very quickly and the pantomime that was playing at the time was soon back on schedule.

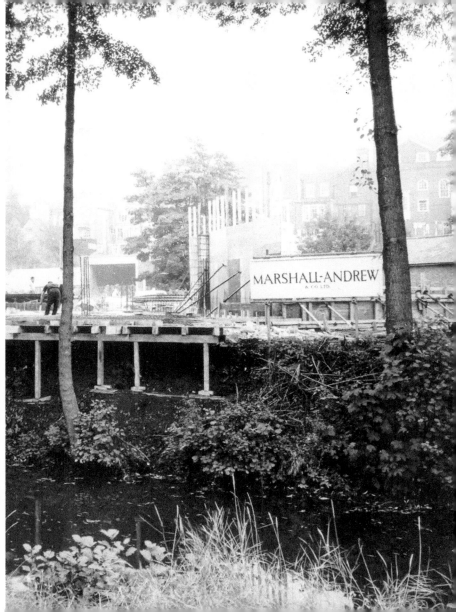

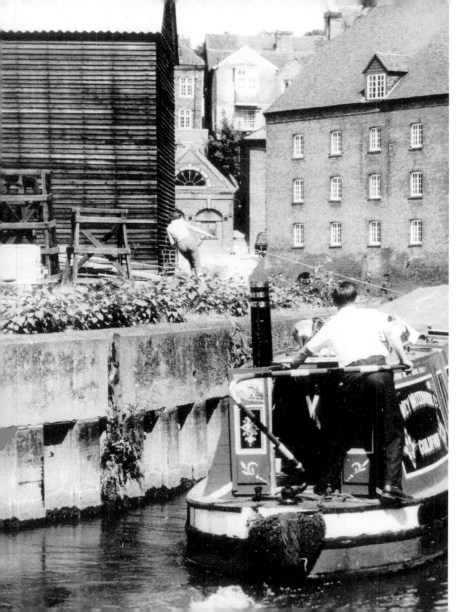

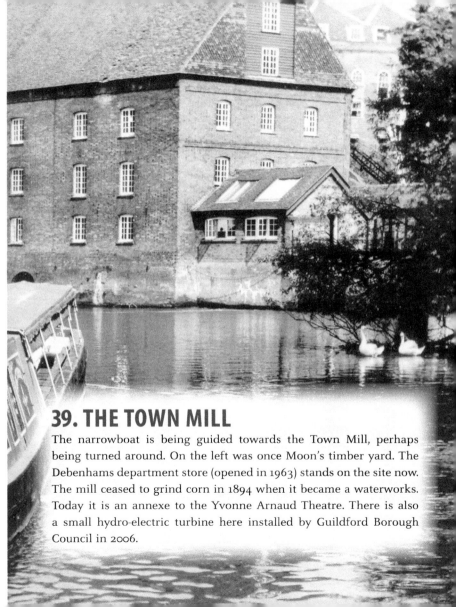

39. THE TOWN MILL

The narrowboat is being guided towards the Town Mill, perhaps being turned around. On the left was once Moon's timber yard. The Debenhams department store (opened in 1963) stands on the site now. The mill ceased to grind corn in 1894 when it became a waterworks. Today it is an annexe to the Yvonne Arnaud Theatre. There is also a small hydro-electric turbine here installed by Guildford Borough Council in 2006.

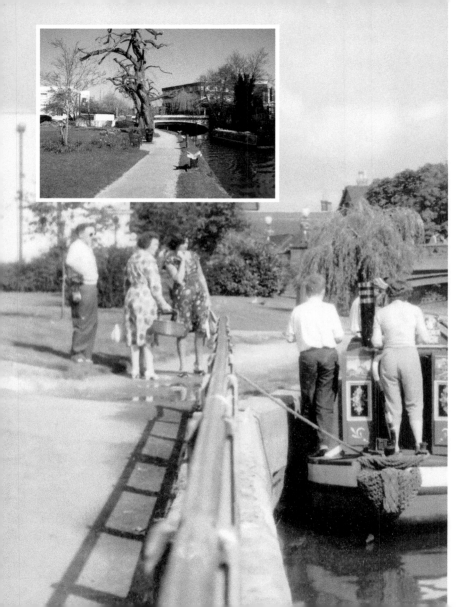

40. BOATING ON THE RIVER WEY

Back in the 1960s there were certainly not as many narrowboats cruising the River Wey for pleasure as there are today. But the boat here appears to be just that, and not used in the traditional sense for transporting cargo. It is however, painted with classic pictures of castles and roses, a traditional art form synonymous with boats on Britain's inland waterways. In fact, cargo was still being transported on the River Wey Navigations (that stretches from Weybridge to Godalming) well into the 1950s. In 1965 it was gifted to the National Trust. The Town Bridge can be seen in the distance.

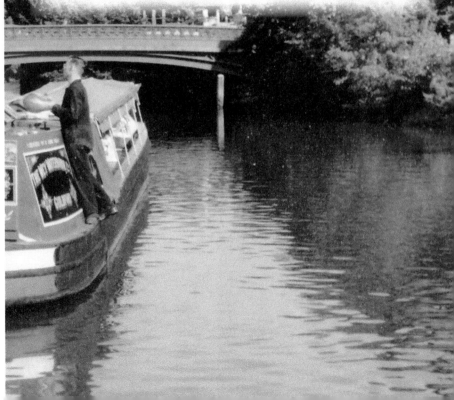

41. ST NICOLAS' CHURCH

This view, looking up towards the High Street from the opposite side of the river, has not changed a great deal. However, one of the buildings on the left-hand side has gone. It was a house occupied by the Crooke family who owned a brewery that was beside the river, now a car park and before that the Farnham Road bus station. St Nicolas' church was consecrated in 1876. It replaced an earlier short-lived nineteenth-century church that was very poorly designed, uncomfortable for the congregation and had a leaky roof!

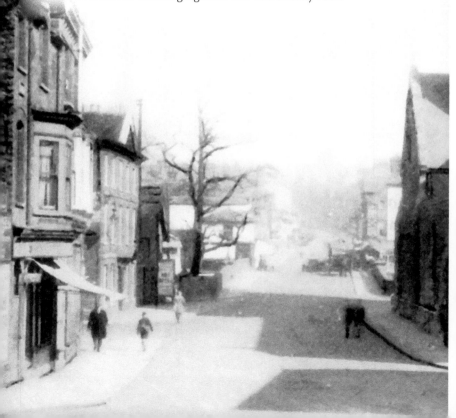

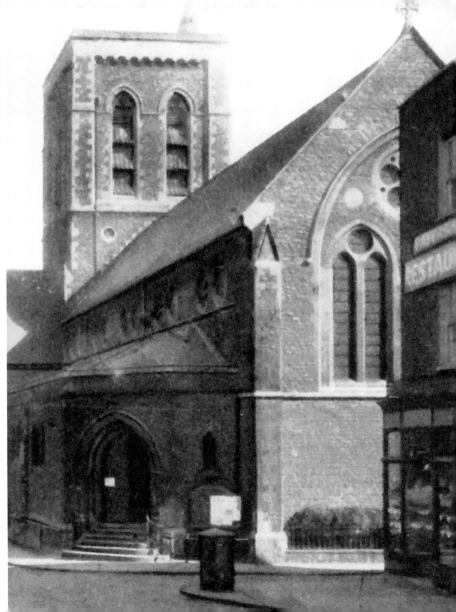

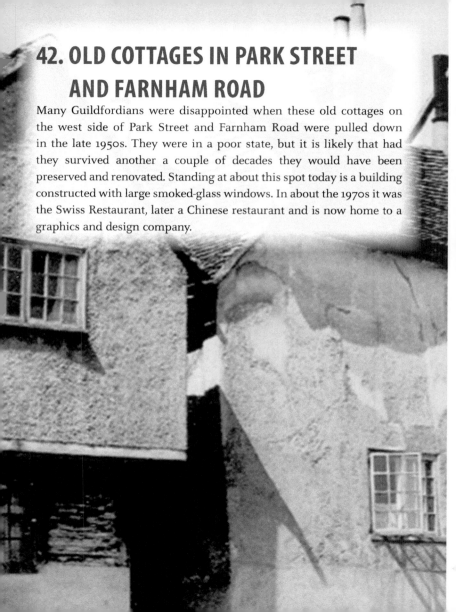

42. OLD COTTAGES IN PARK STREET AND FARNHAM ROAD

Many Guildfordians were disappointed when these old cottages on the west side of Park Street and Farnham Road were pulled down in the late 1950s. They were in a poor state, but it is likely that had they survived another a couple of decades they would have been preserved and renovated. Standing at about this spot today is a building constructed with large smoked-glass windows. In about the 1970s it was the Swiss Restaurant, later a Chinese restaurant and is now home to a graphics and design company.

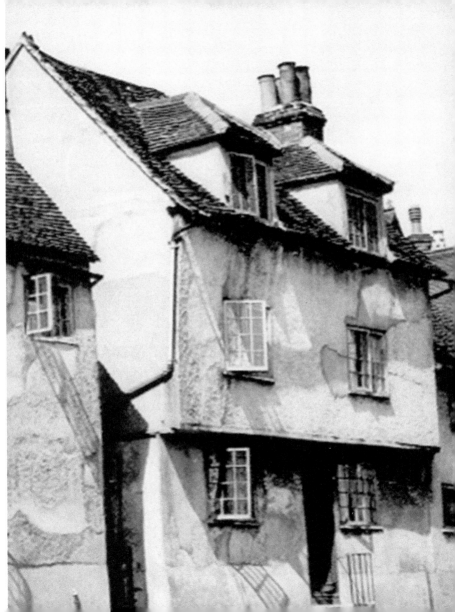

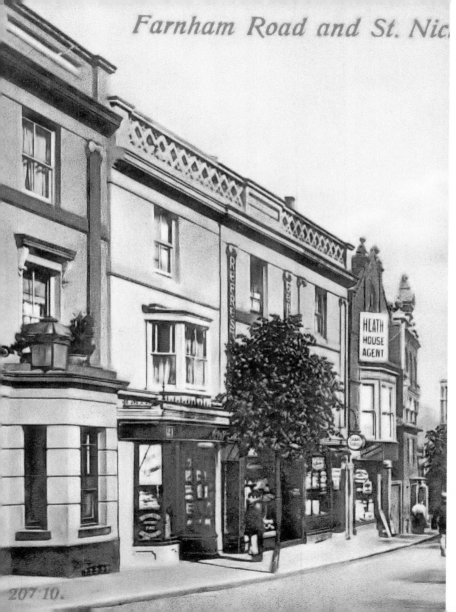

Farnham Road and St. Nic...

HEATH
HOUSE
AGENT

207 10.

43. FARNHAM ROAD

The road is now part Guildford's gyratory system and is a bottle-neck for traffic that tries to make its way through the town, essentially a gap in the North Downs. On the far left can be seen the Napoleon Hotel that has long gone. Traders who were once here in buildings also now demolished included estate agents and auctioneers Heath & Salter, Brett's bakers and wine and spirits merchants Arthur Cooper. Further down was the Castle pub and Guildford's Technical Institute.

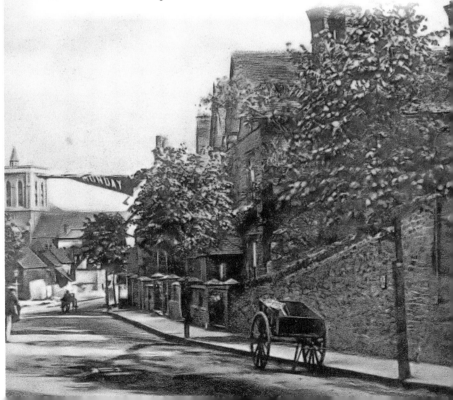

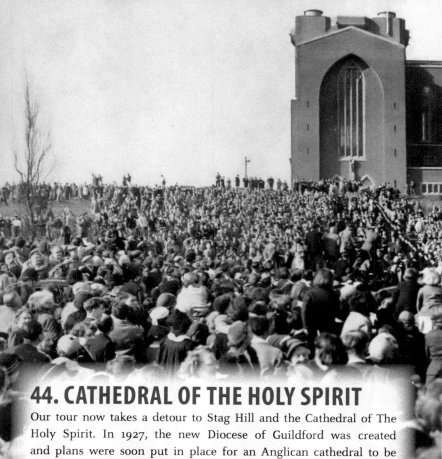

44. CATHEDRAL OF THE HOLY SPIRIT

Our tour now takes a detour to Stag Hill and the Cathedral of The Holy Spirit. In 1927, the new Diocese of Guildford was created and plans were soon put in place for an Anglican cathedral to be built in the town. It was designed by Sir Edward Maufe and work began in 1936. However, construction was halted during the Second World War but was resumed in the 1950s along with a number of fundraising campaigns and events. Here we see an Easter pilgrimage in 1955. It was consecrated by the Queen in 1961.

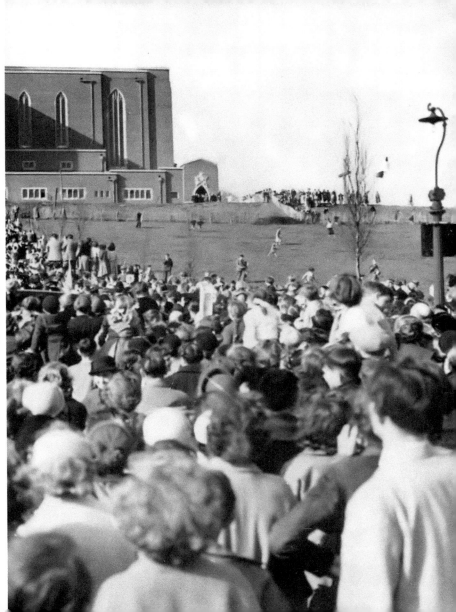

45. STATION APPROACH FROM BRIDGE STREET

This tour of Guildford ends back at the railway station. In this scene, crowds have gathered to catch a glimpse of the Queen when she arrived at the station in 1964. She continued her journey by car to open the new Women's Royal Army Corps' camp at Stoughton. On the right is Bridge house, which had a petrol station at ground level with offices above. It was demolished in the early 1980s and a new Bridge House built on the site. Guildford has indeed changed in recent decades. With a new local plan being prepared to take the town up to 2045, more change, hopefully for improvements to suit all, is likely to be proposed.

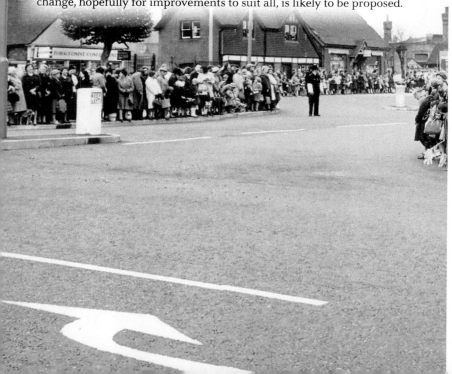